Welcome!

Thank you so much for purchasing a copy of JJ's Fantasy-Inspired Adult Coloring Book. I am honored by the compliment of you choosing my artwork for your next coloring project!

The images in this book are printed on one side of the page only, to help prevent marker bleed-through, and there is a test page at the beginning of the book so you can check how your art materials interact with the paper.

The portraits and scenes in this book are designed to sweep you into alternate worlds full of fantastical creatures, ethnic diversity, and gentle humor.

May you find peace and delight in your coloring!

Test Page

Test your art materials here! Some markers do bleed on this type of paper, and it's better to learn that here rather than spoiling a picture you were looking forward to coloring!

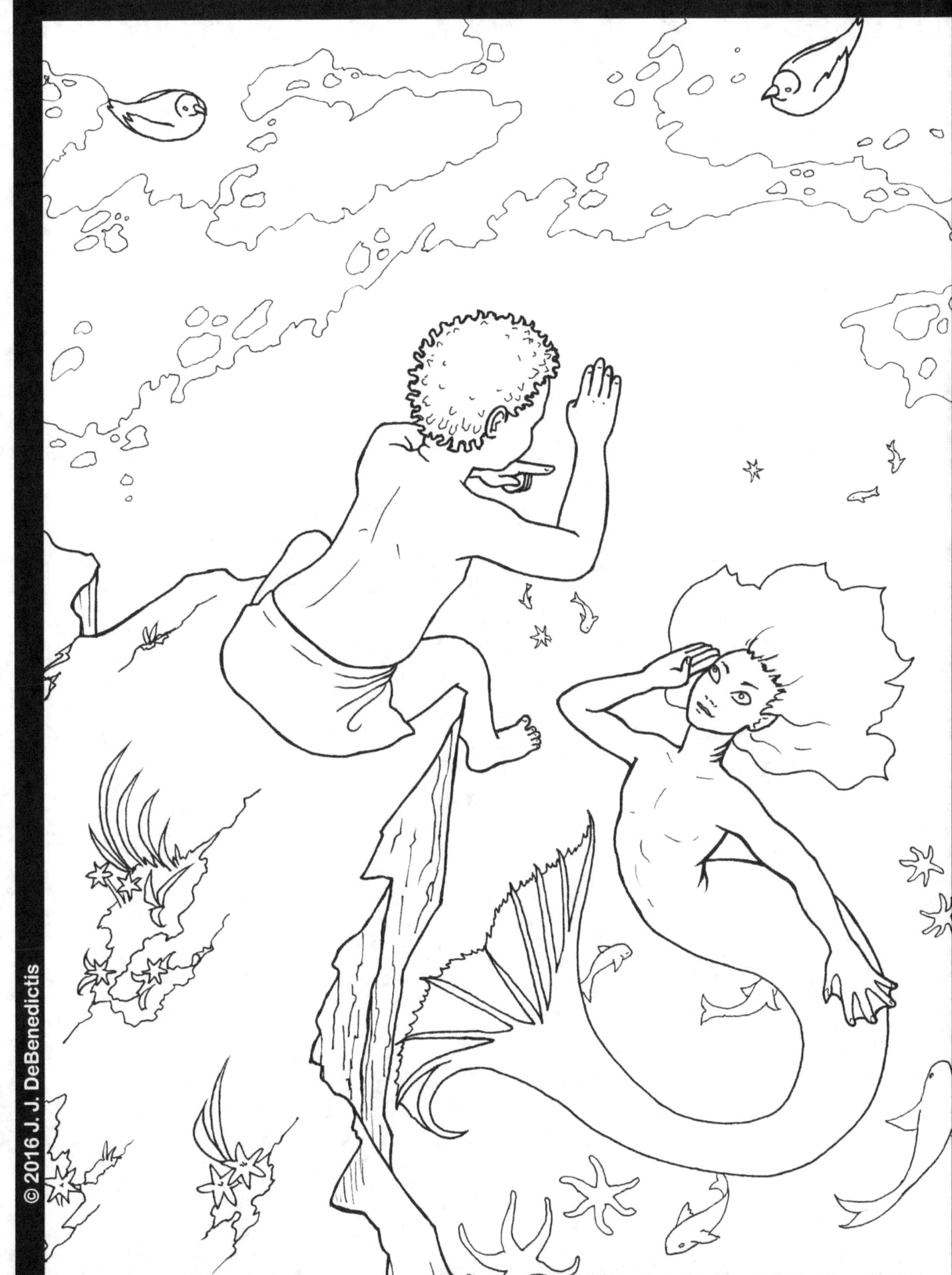

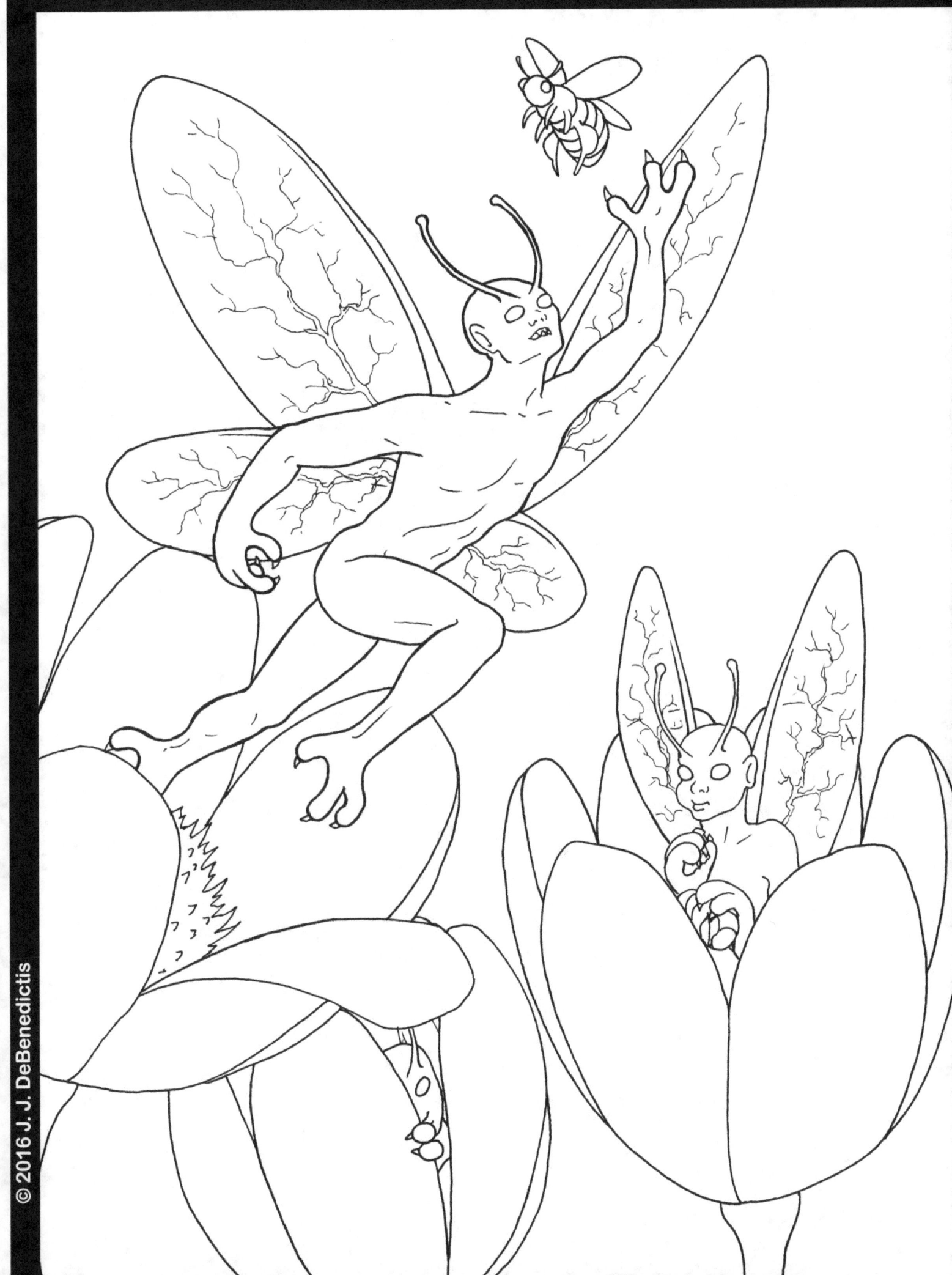

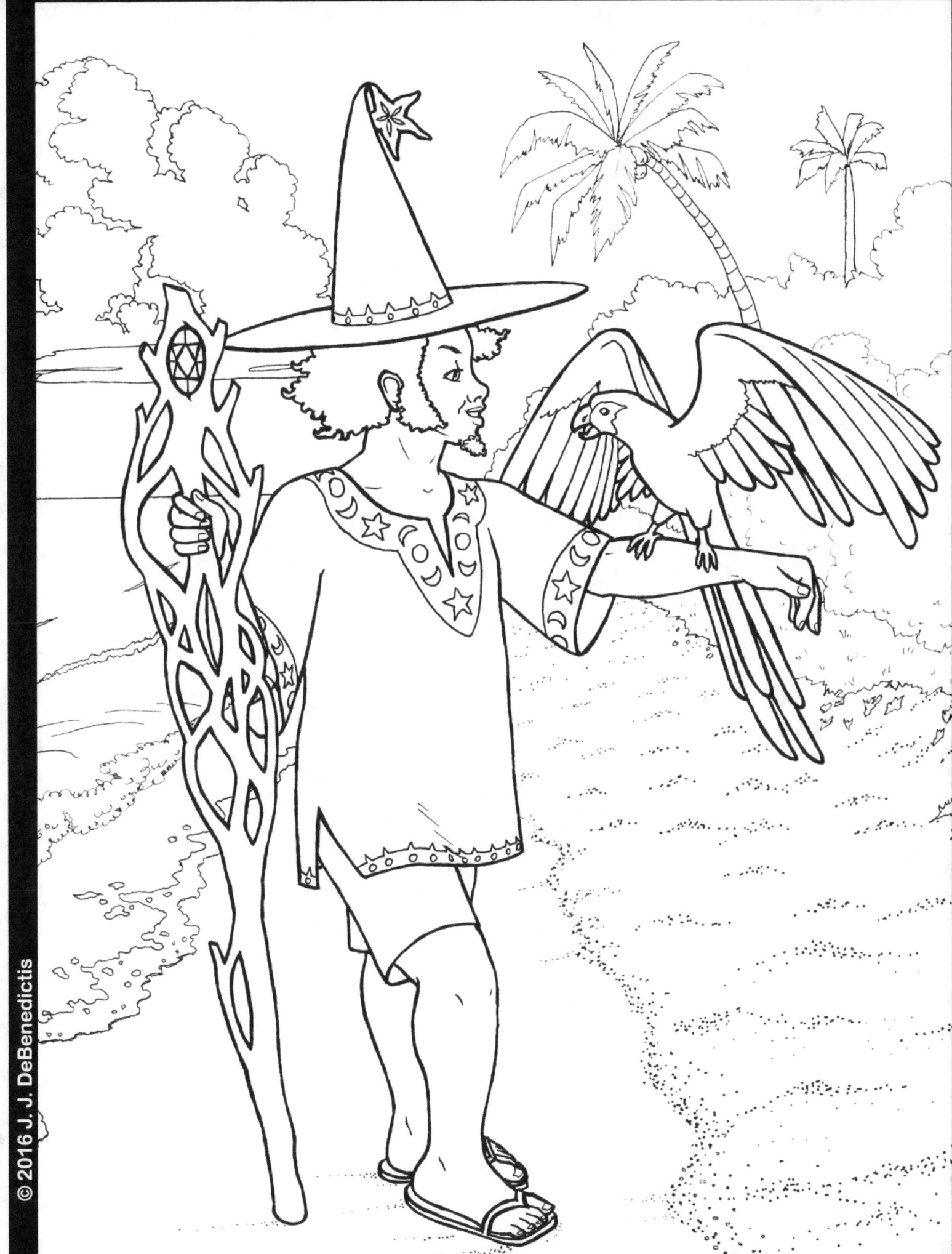

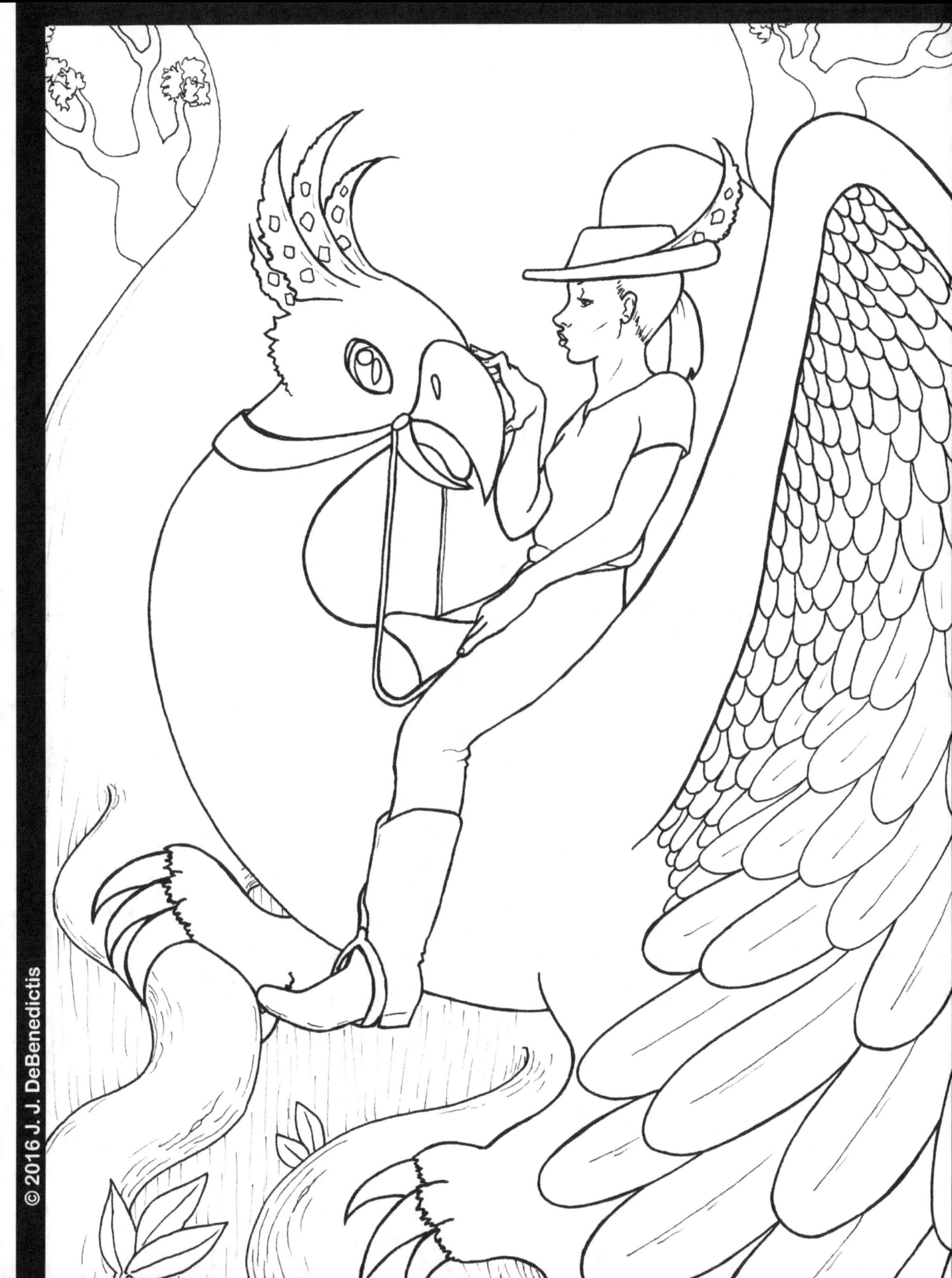

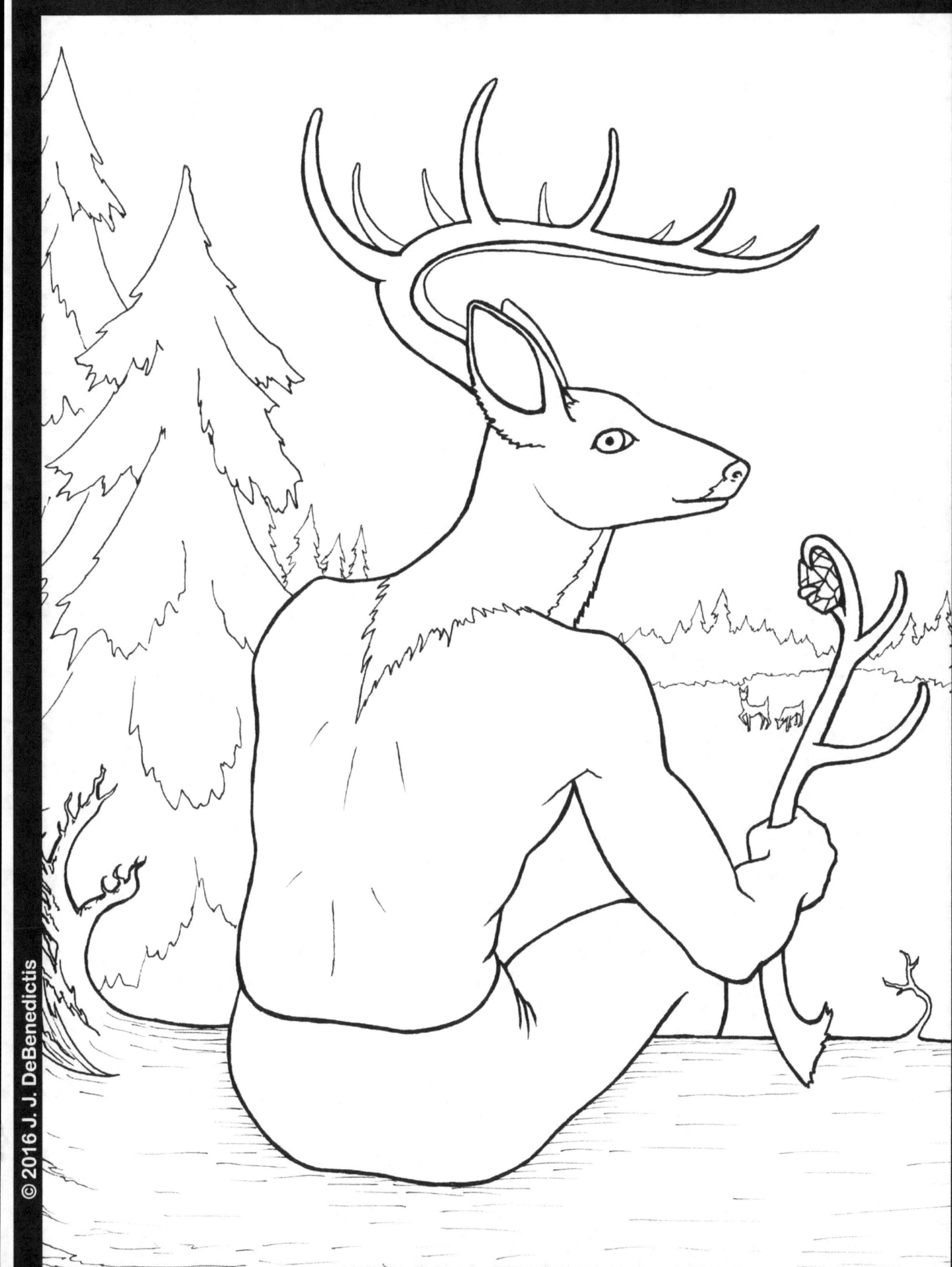

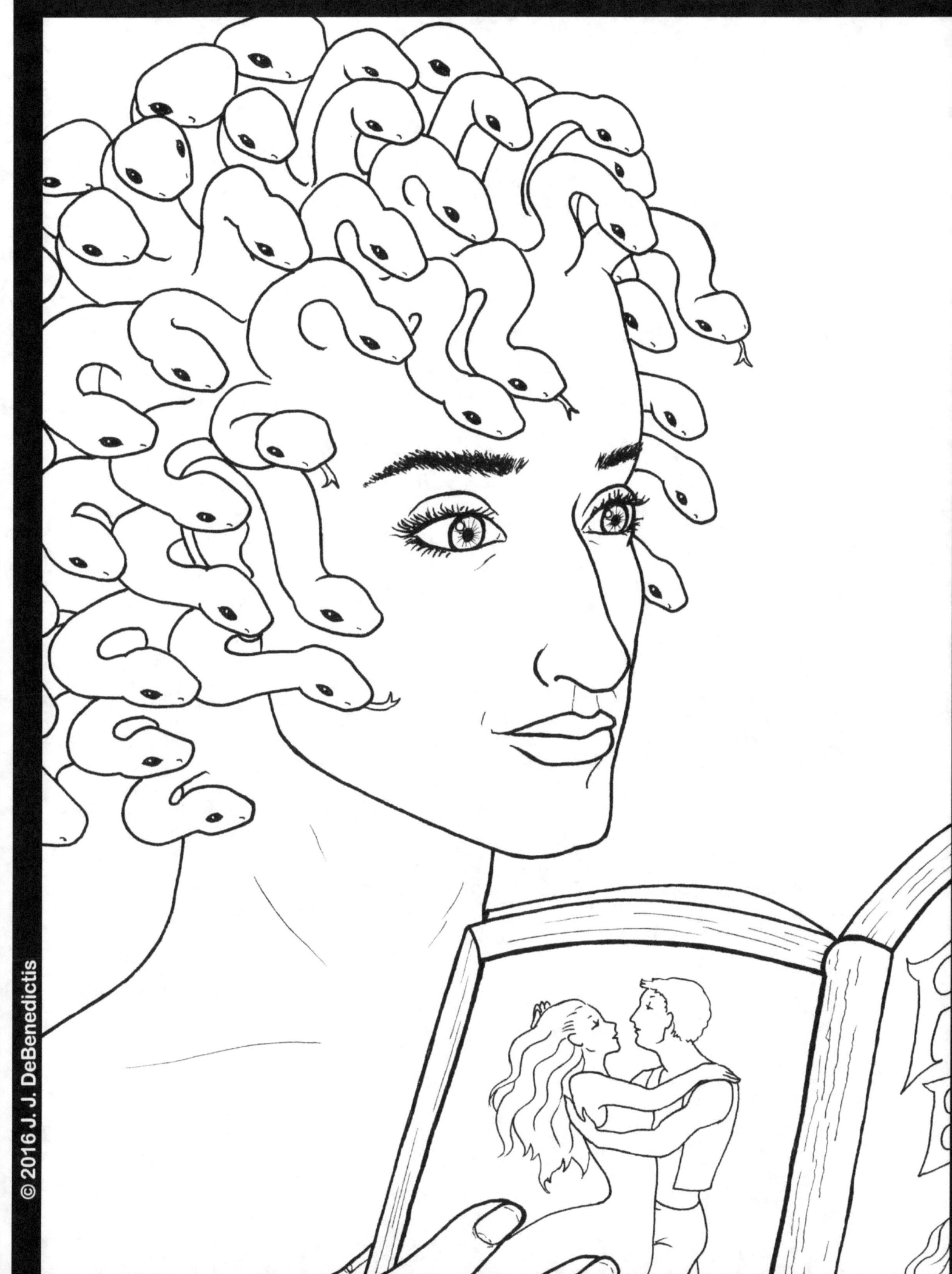

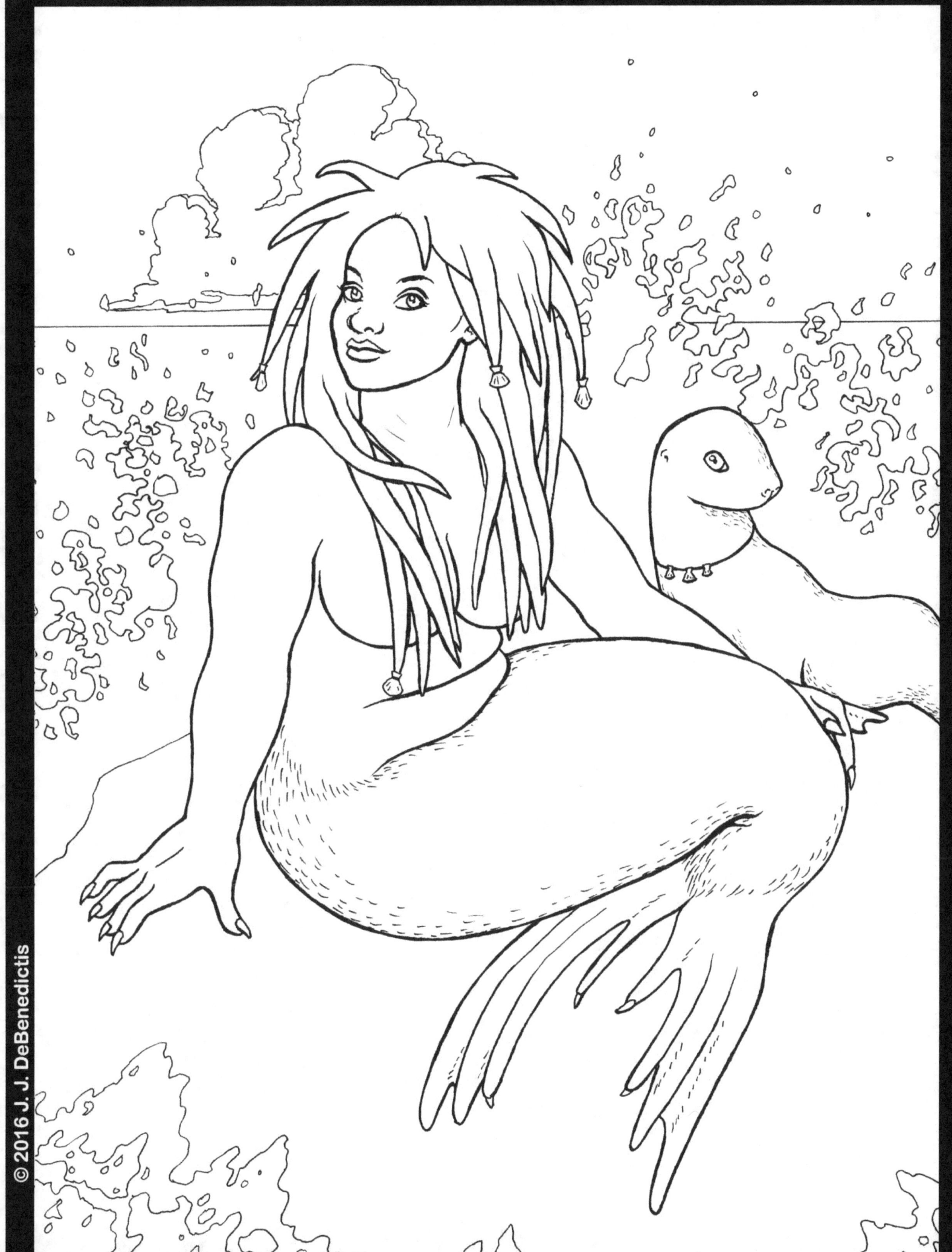

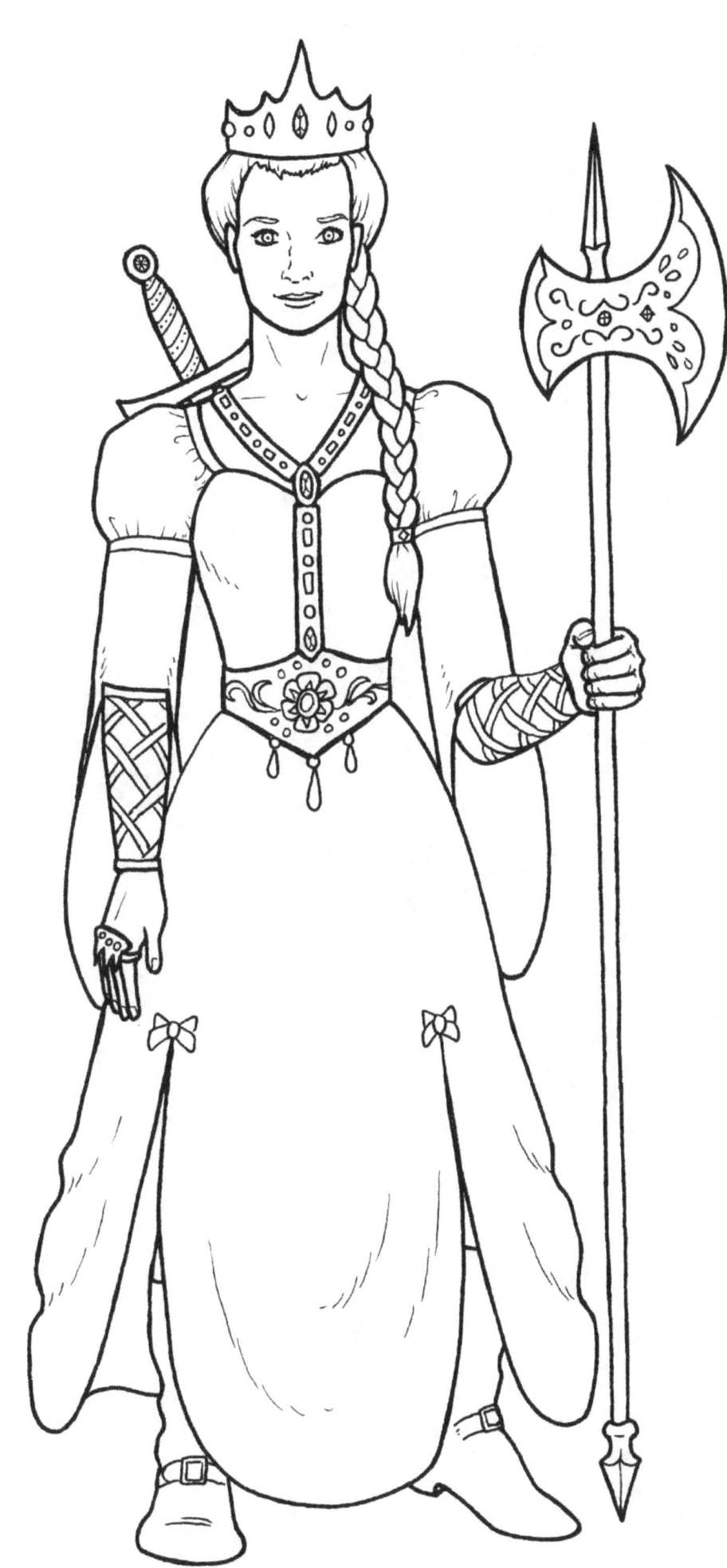

Thank you!

Thank you again for your purchase of my coloring book. I sincerely hope you enjoyed it and are both pleased with and proud of your finished artworks!

You can check for more of my works (and preview the images for them) at my website, www.jjdebenedictis.com/ColoringBooks

Also, if you enjoyed this book, please consider telling a friend or leaving an online review. Word-of-mouth is one of the best ways to help your fellow coloring enthusiasts discover great books!

Sincerely, and with best wishes,
JJ

To learn more about the artist, please visit:
www.jjdebenedictis.com